Norman Rockwell Classics

from **THE SATURDAY EVENING POST**

COLORING BOOK

RENDERED FOR COLORING BY
SARA JACKSON

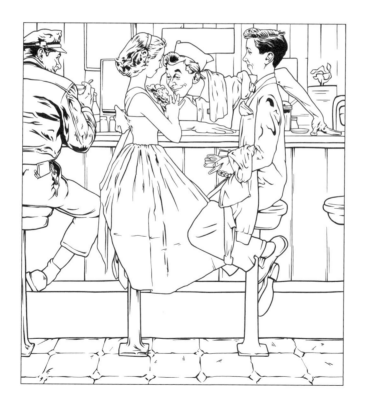

DOVER PUBLICATIONS, INC.
MINEOLA, NEW YORK

Born in 1894 in New York City, illustrator Norman Rockwell is perhaps best known for the more than three hundred covers that he painted for the iconic *Saturday Evening Post,* in which he portrayed people typical of small-town America. Offering accurate, detailed depictions of everyday life, Rockwell's humorous renderings of often-commonplace events have the special ability to tell a story. Though many of the pictures relate to an earlier time, people of all ages continue to enjoy this artist's unique ability to make someone laugh or to make the best out of a situation with "a picture worth a thousand words."

Thirty-one of Norman Rockwell's classic covers are rendered here in this distinctive and unique coloring book, which celebrates the legacy of this legendary artist. The title of the artwork and the date that it appeared as a *Saturday Evening Post* cover are printed on the back of each coloring plate. After coloring, remove the perforated pages from the book and display your own artistic treasury of "Rockwell's America."

Bibliographical Note

Norman Rockwell Classics from The Saturday Evening Post Coloring Book
is a new work, first published by Dover Publications, Inc., in 2017.

International Standard Book Number

ISBN-13: 978-0-486-81435-3
ISBN-10: 0-486-81435-1

Manufactured in the United States by LSC Communications
81435102 2017
www.doverpublications.com

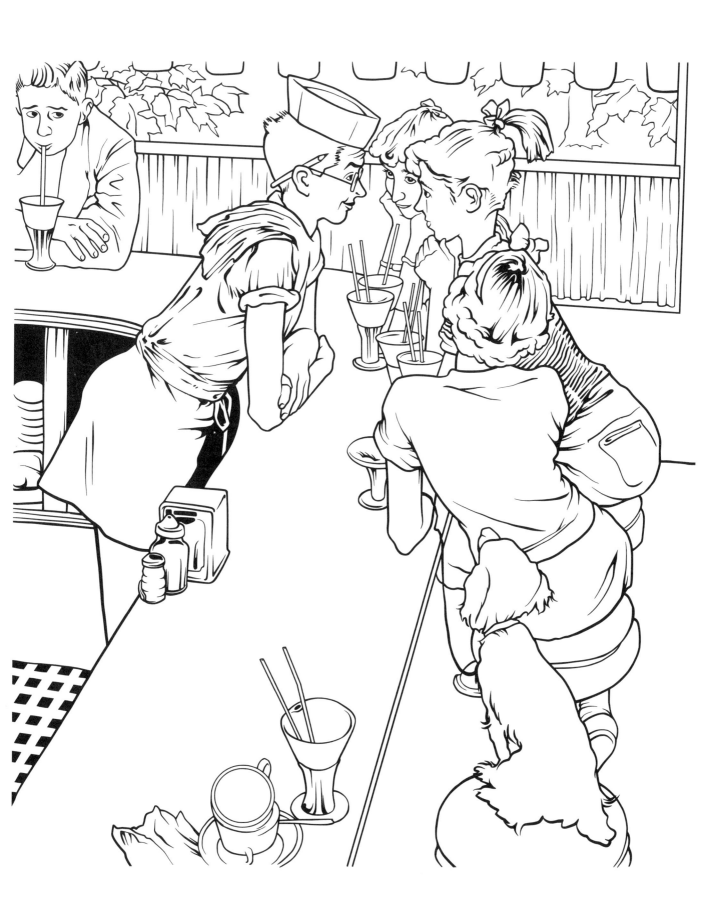

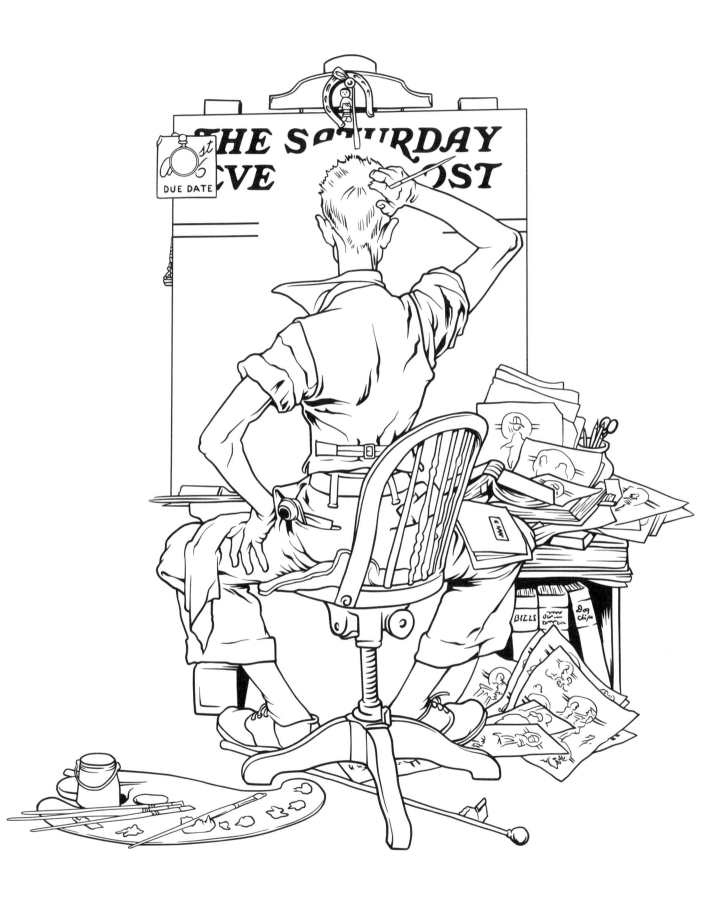

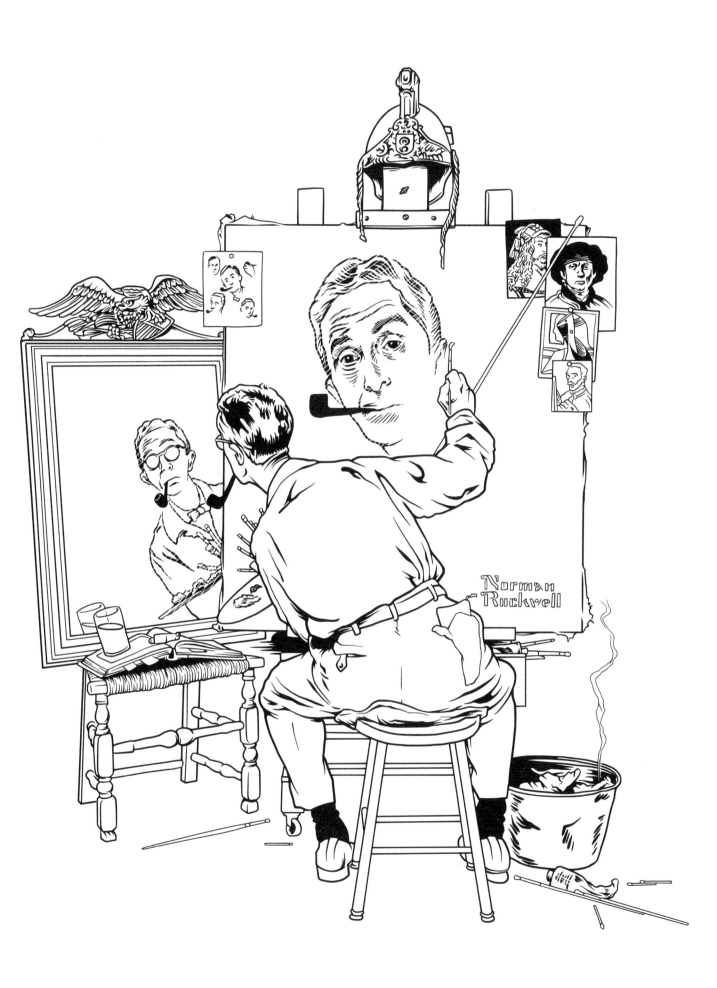

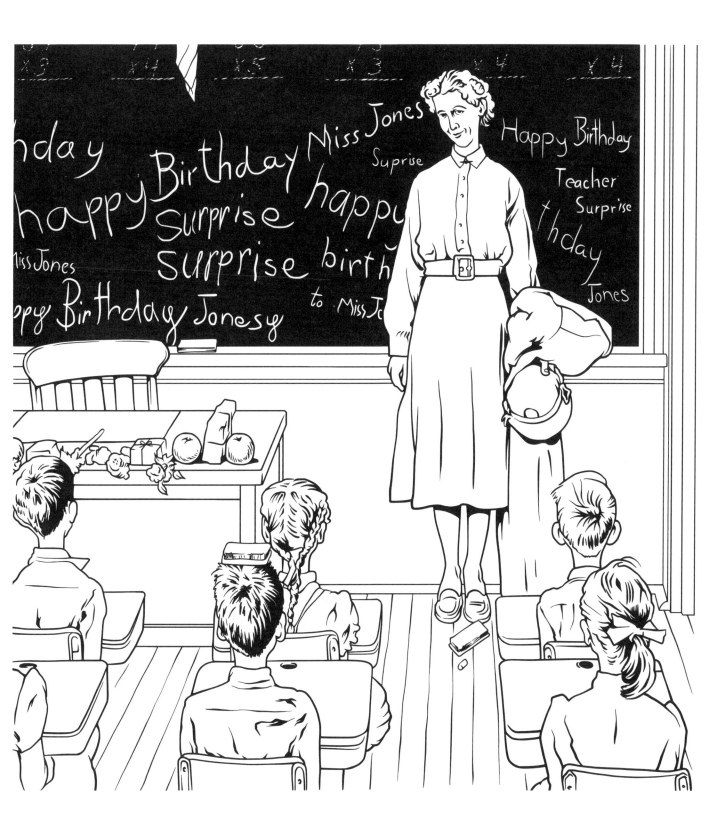

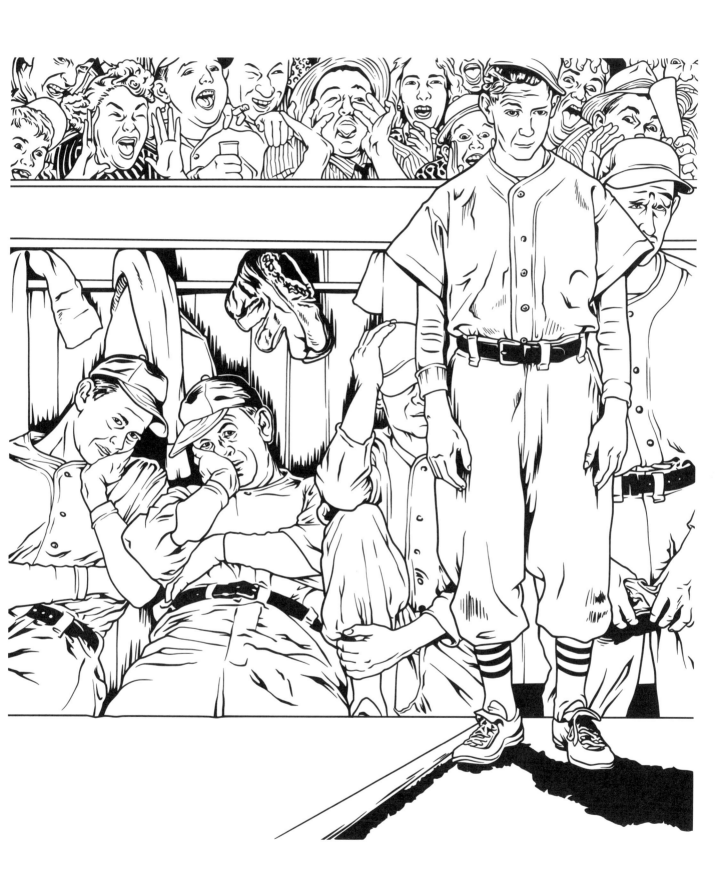

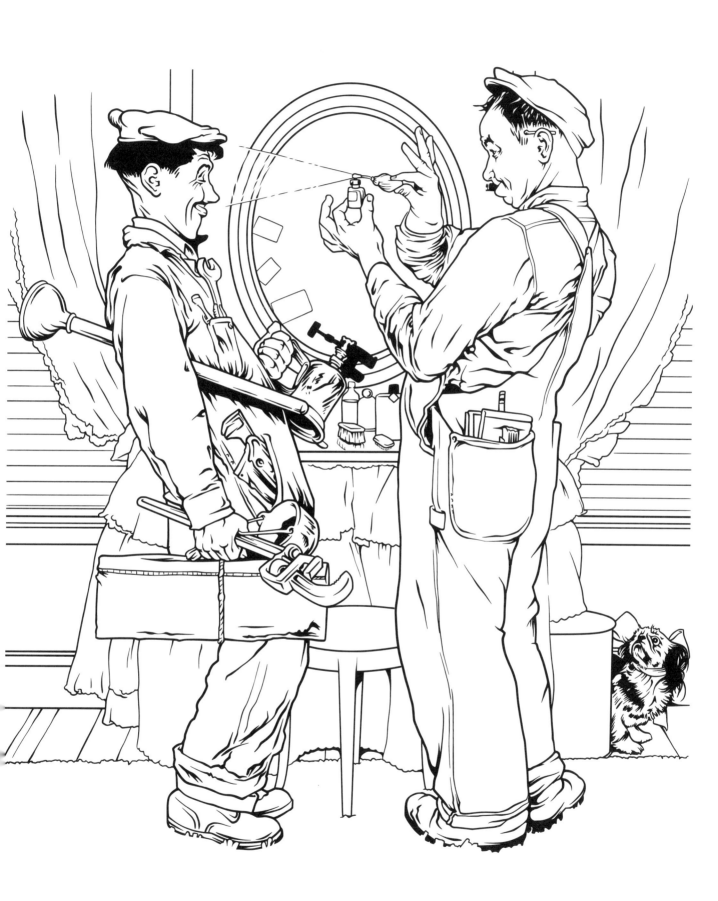

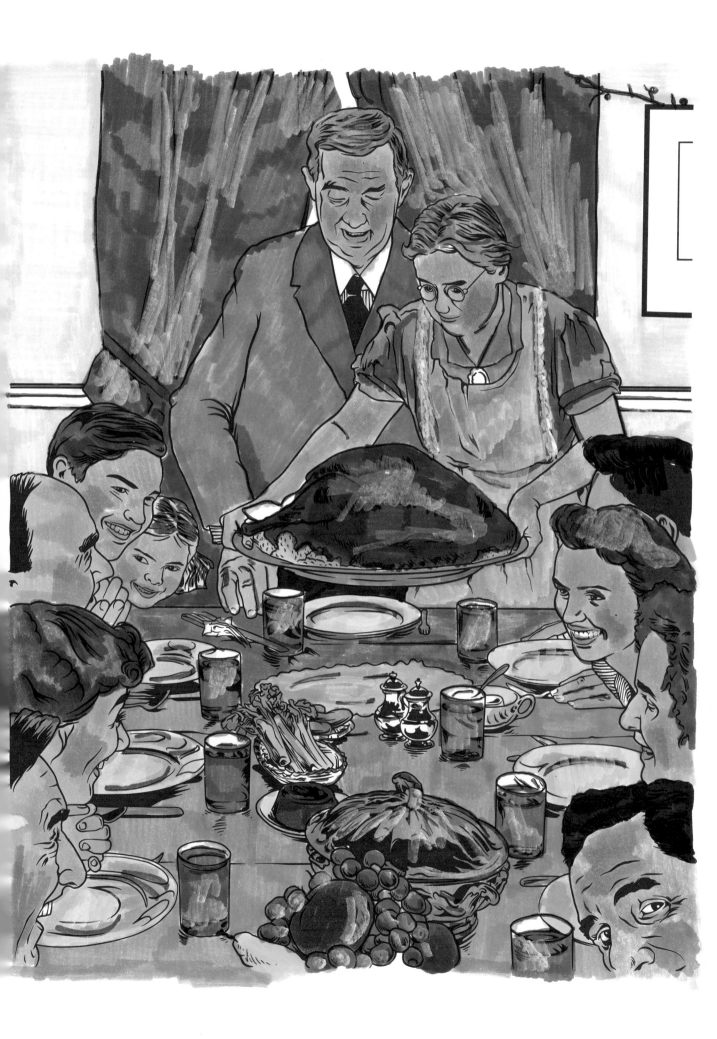

PLATE 7
Freedom from Want
Norman Rockwell
The Saturday Evening Post cover, March 6, 1943
Illustration © Rockwell Family Agency, Inc.
Images provided by Curtis Licensing, Indianapolis, Indiana

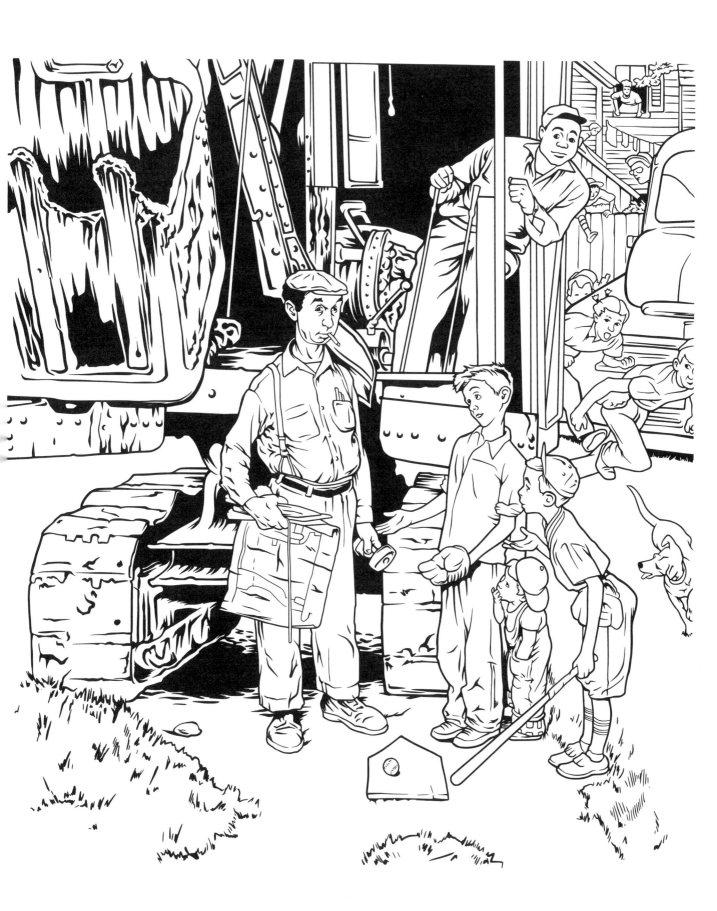

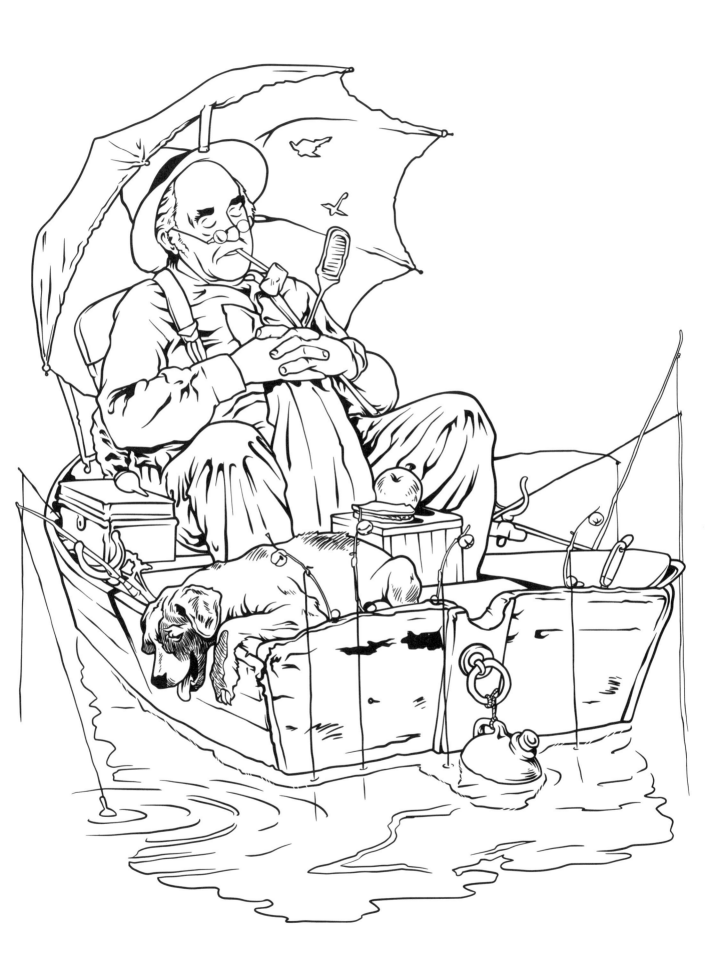

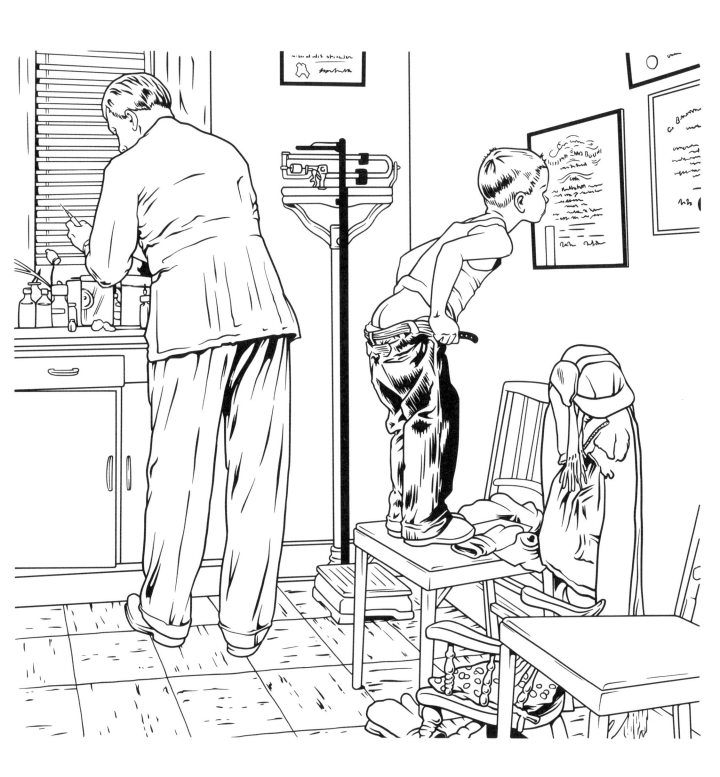

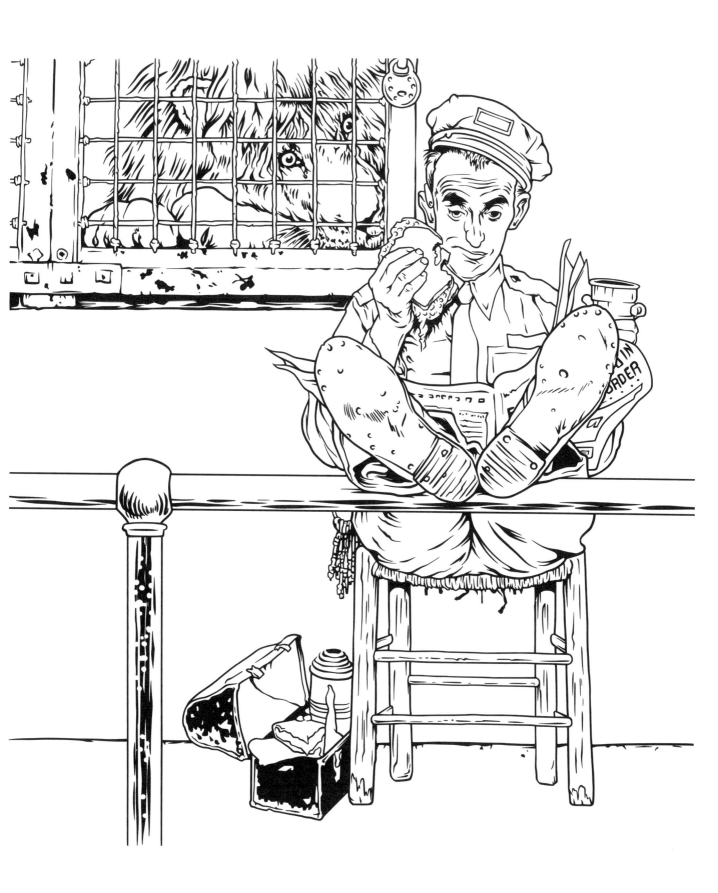

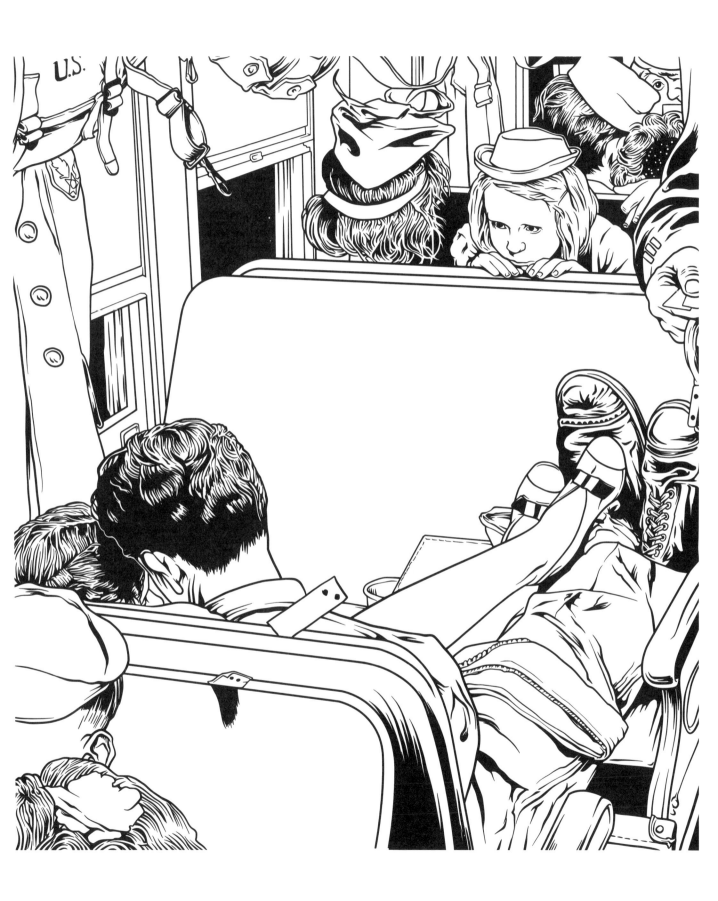

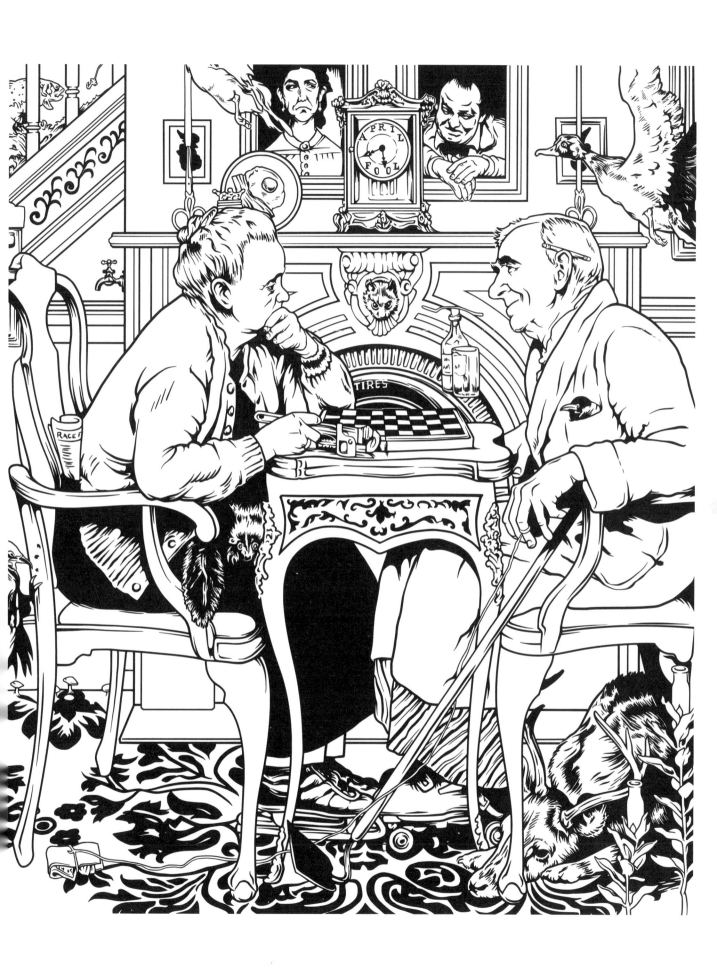

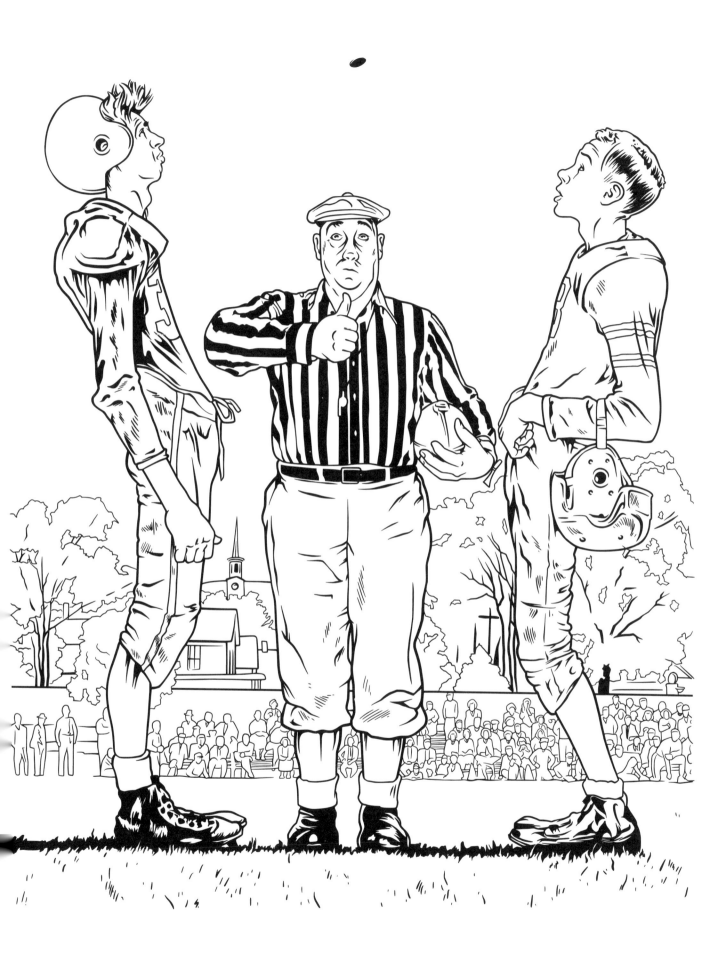

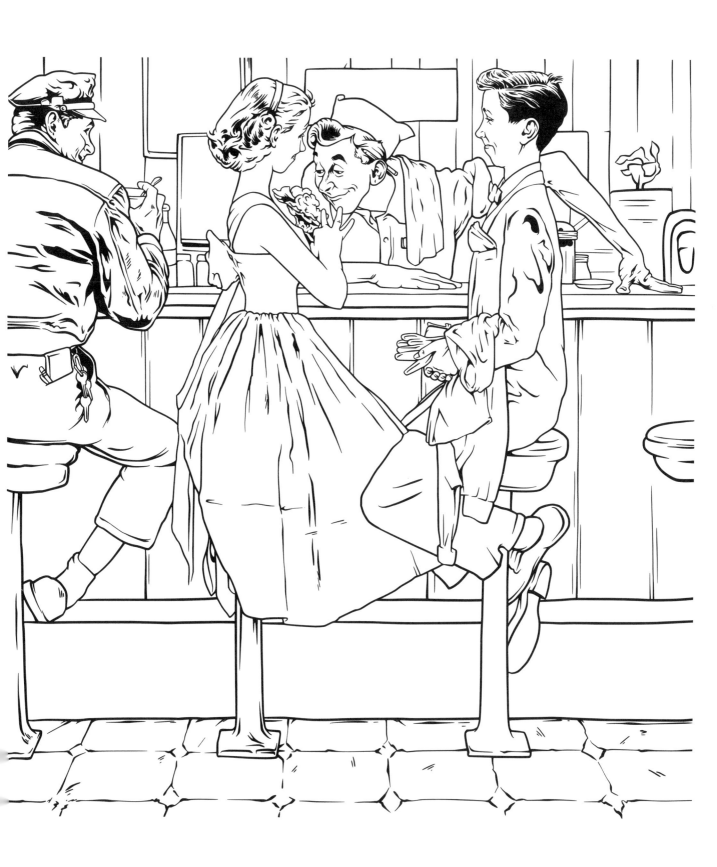

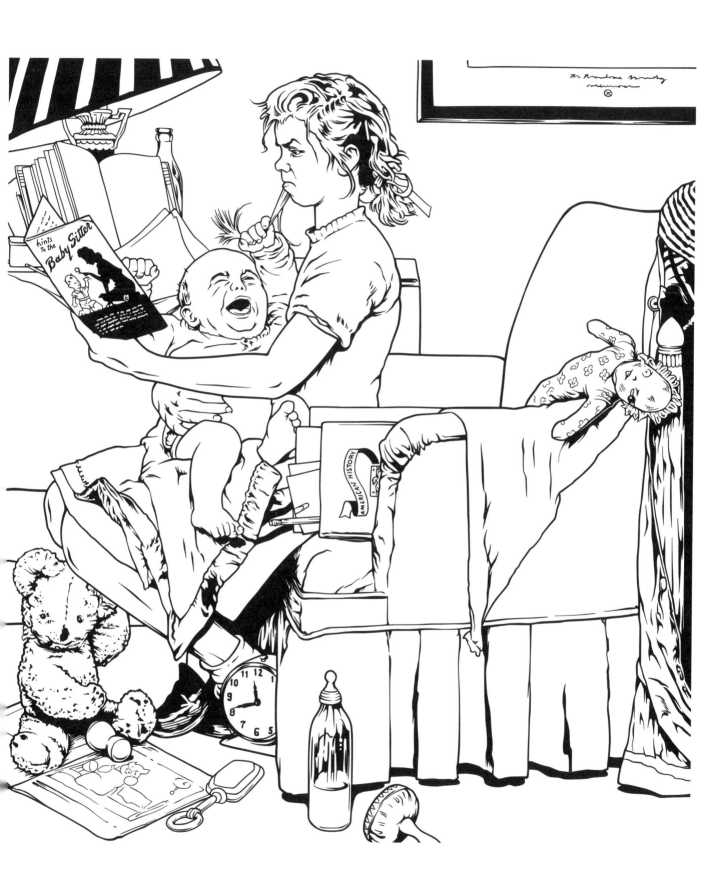

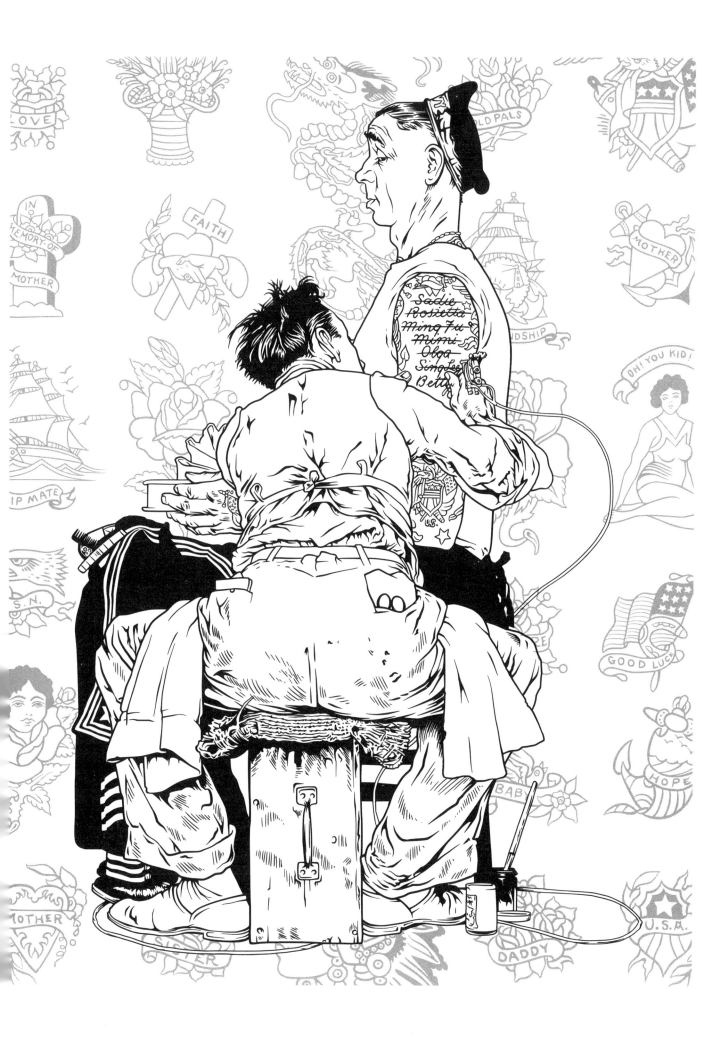

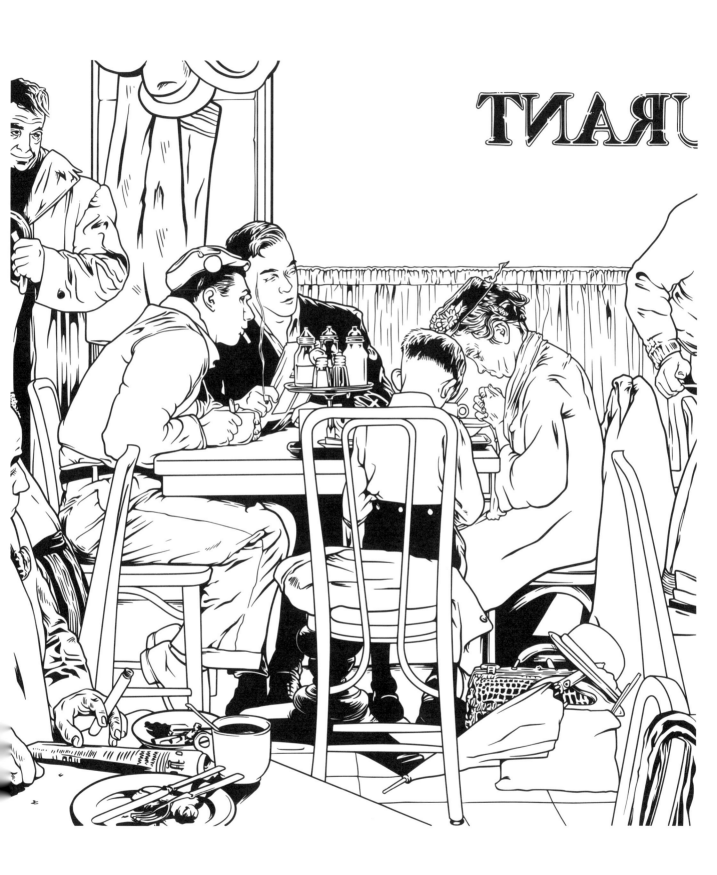

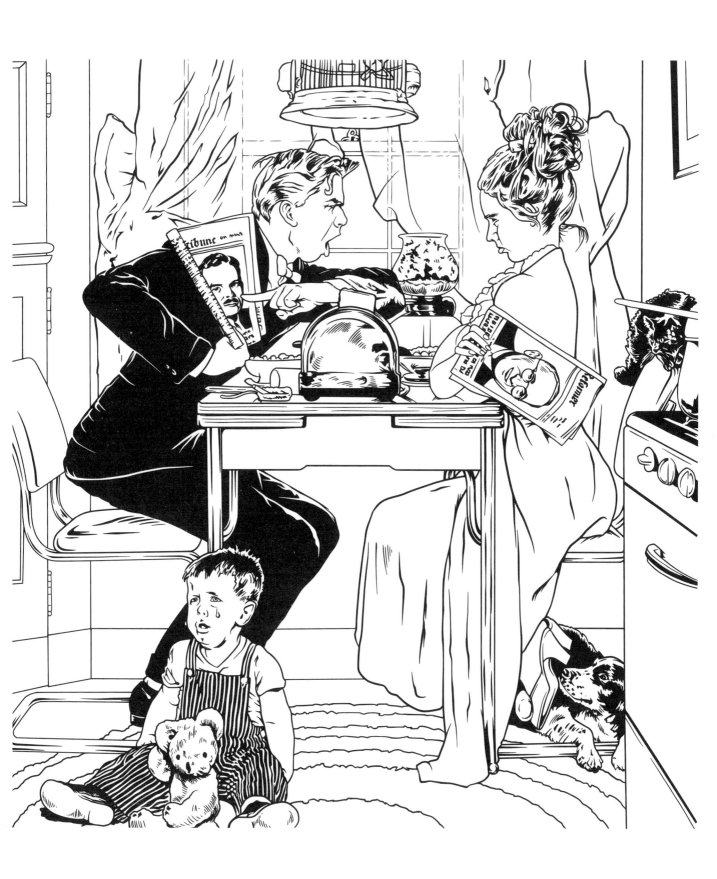

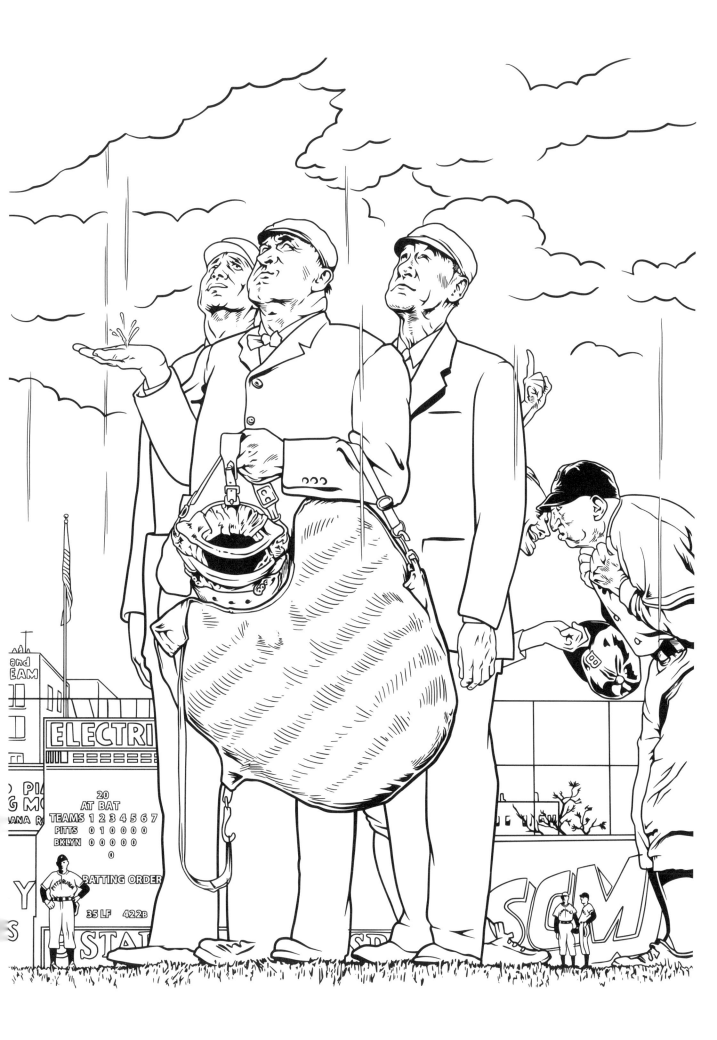

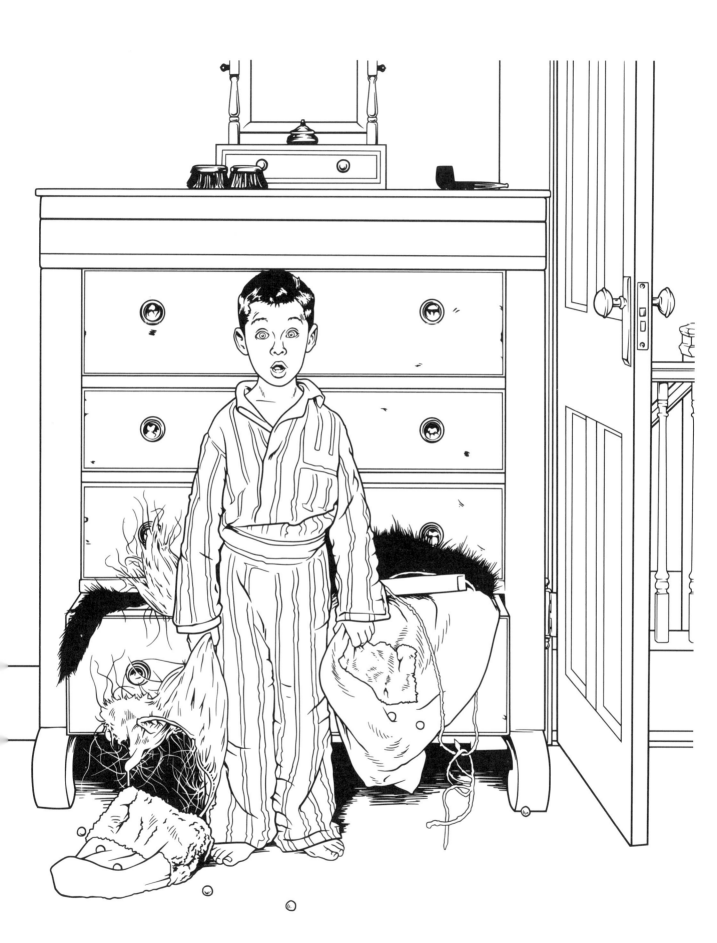

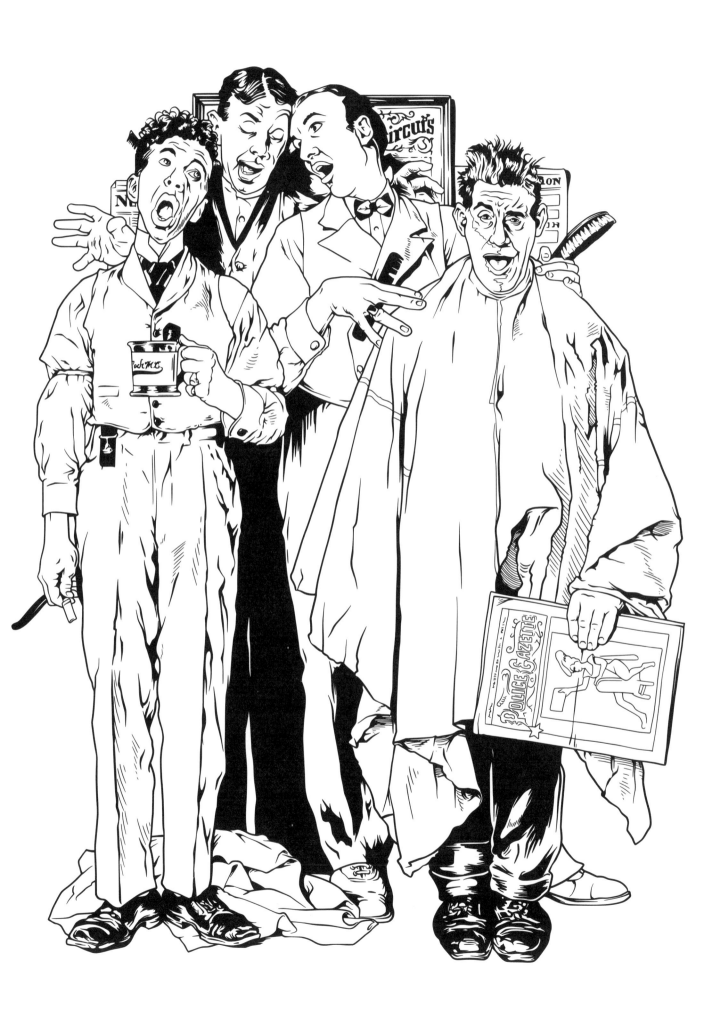

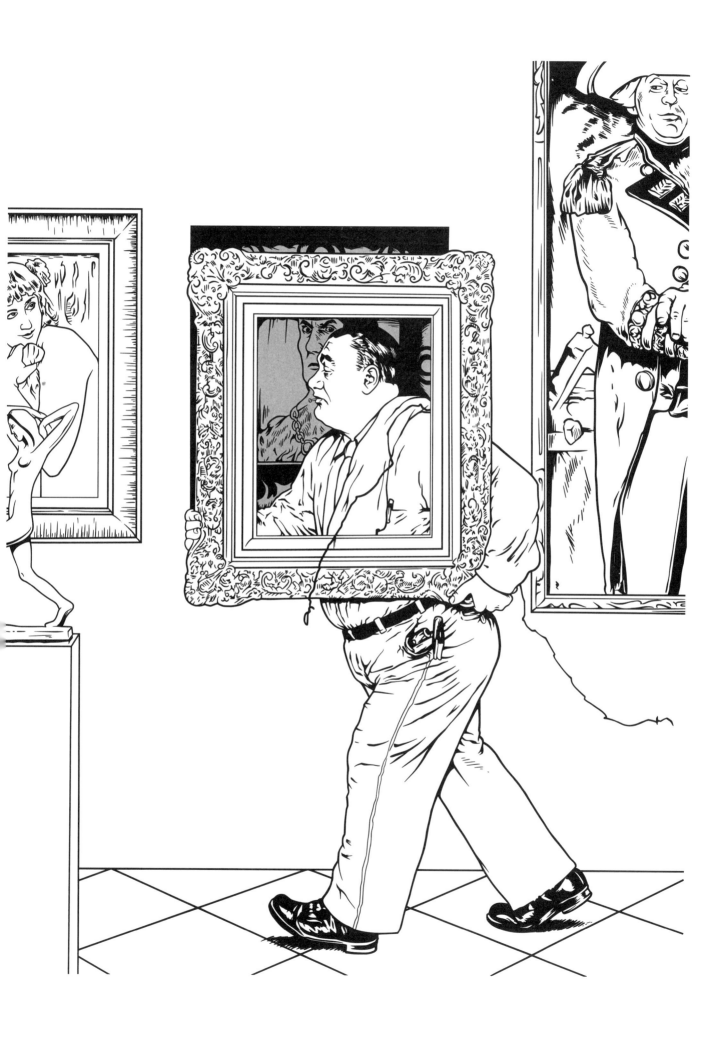

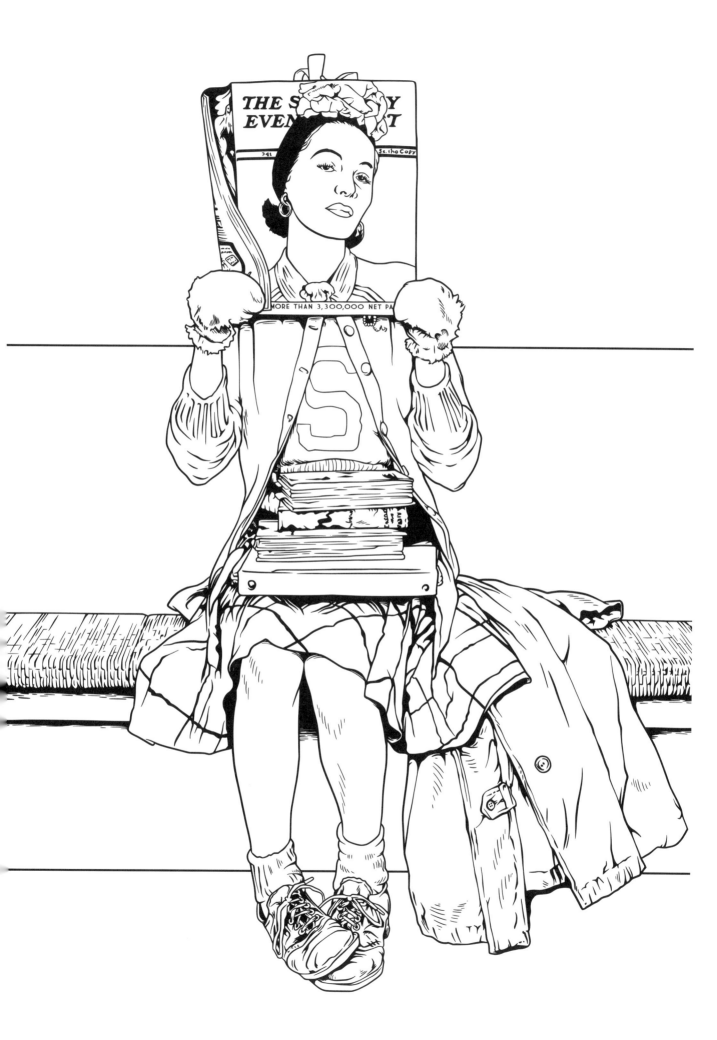

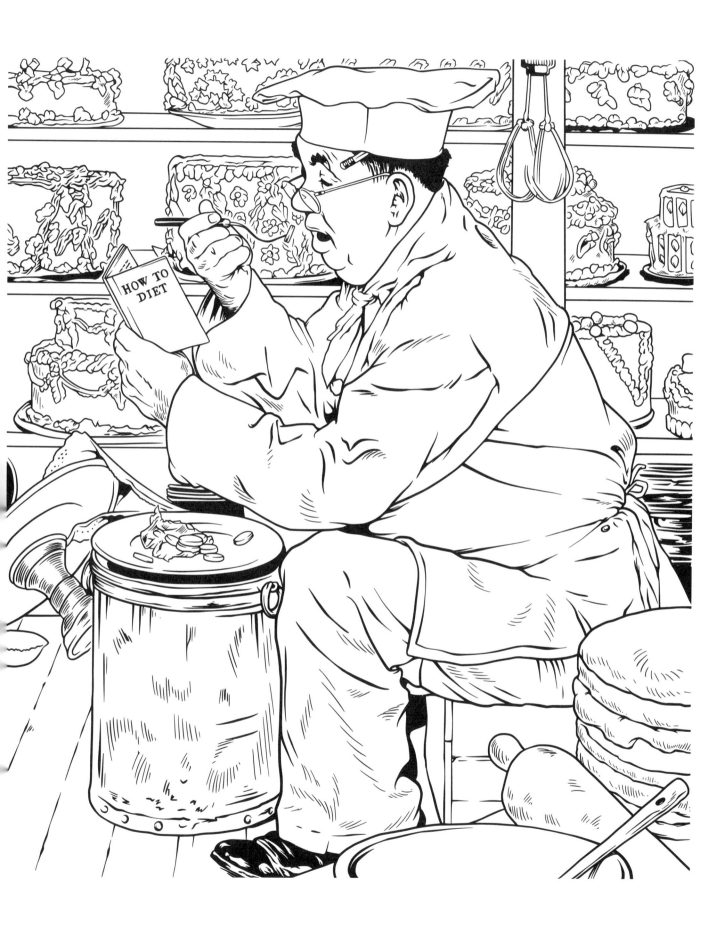

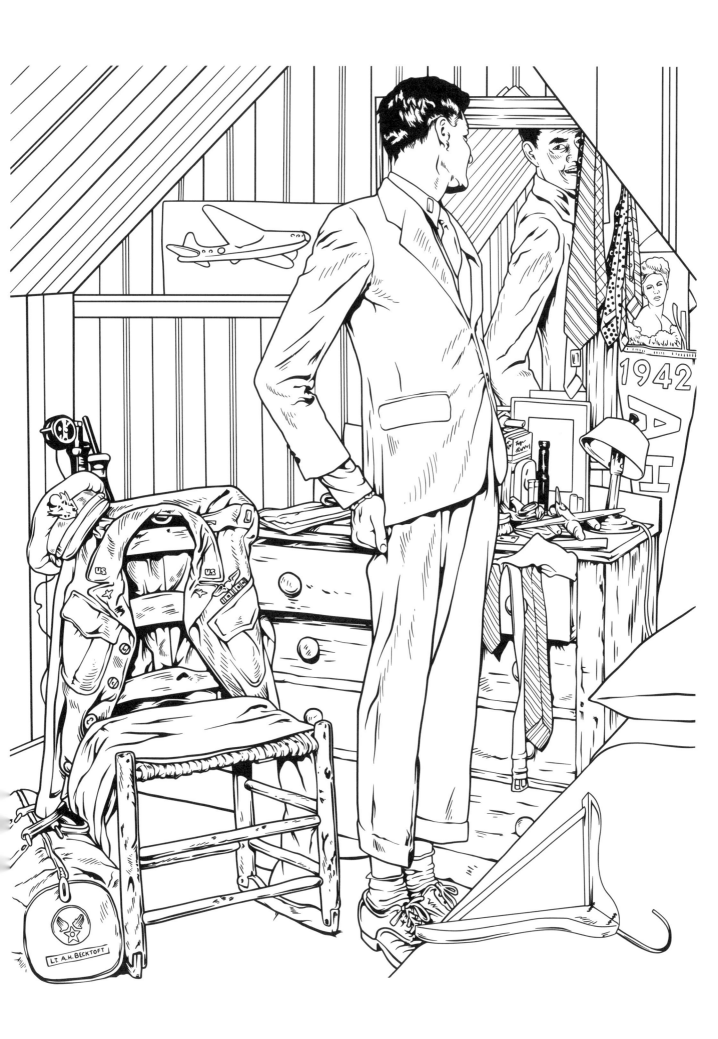

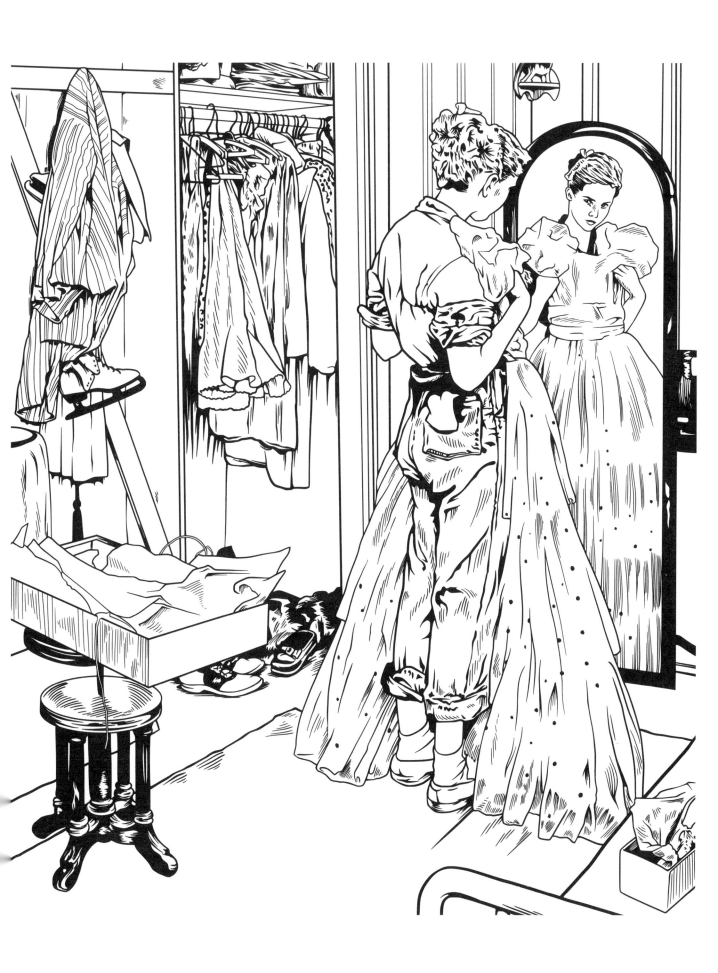

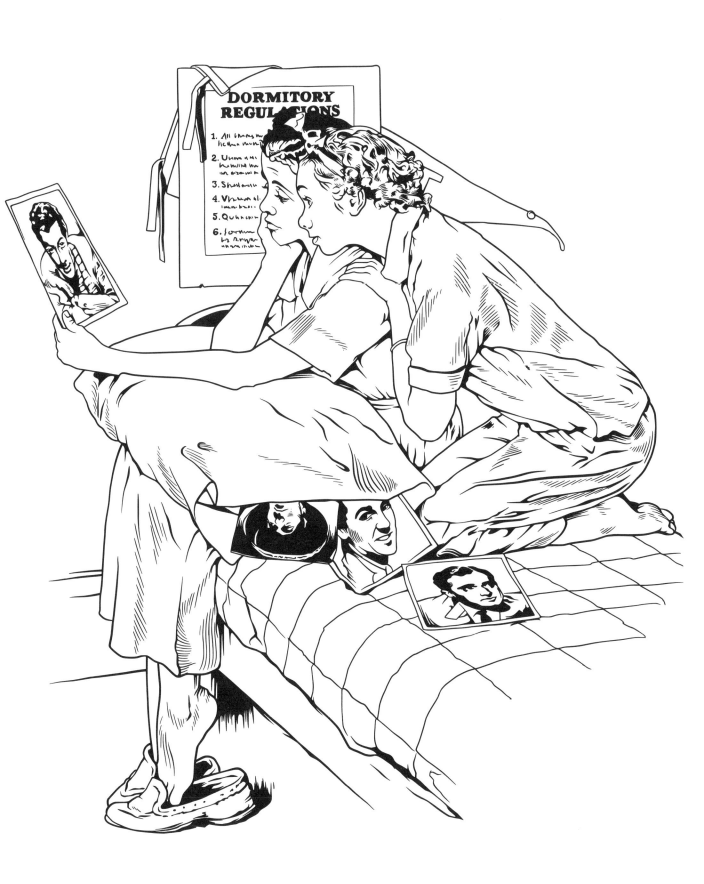

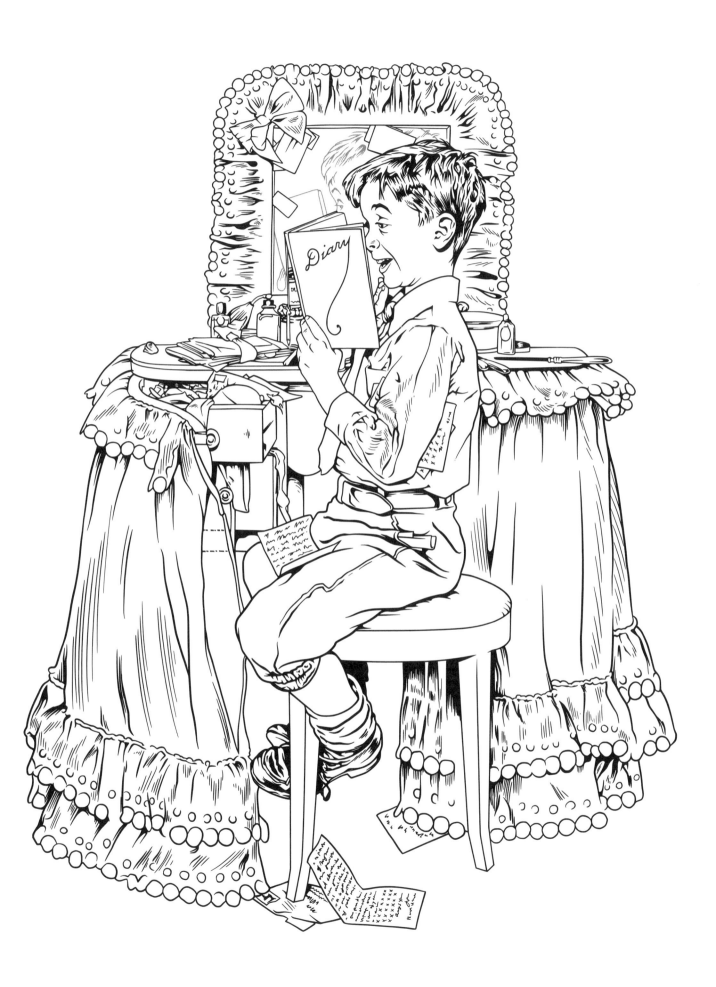

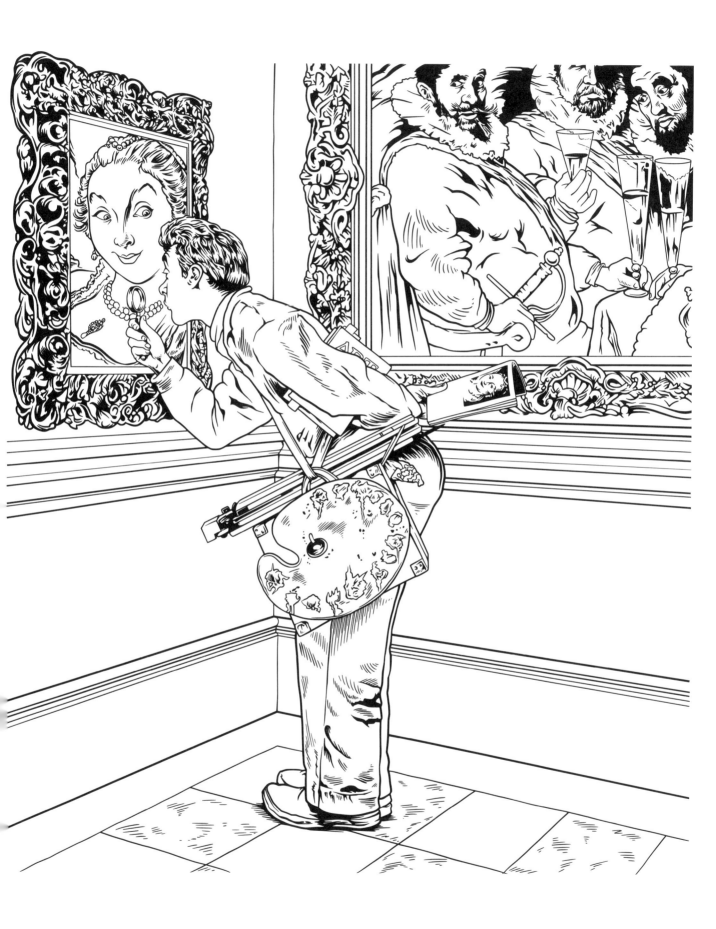

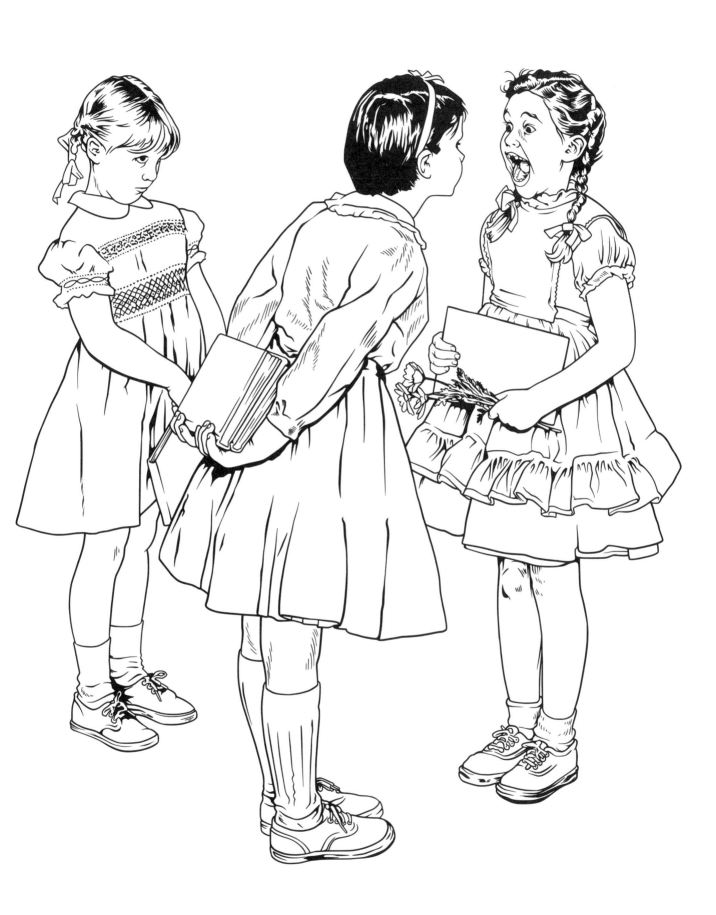